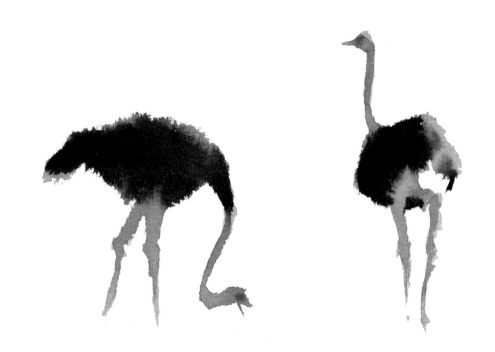

LEARN
WATERCOLOUR
QUICKLY

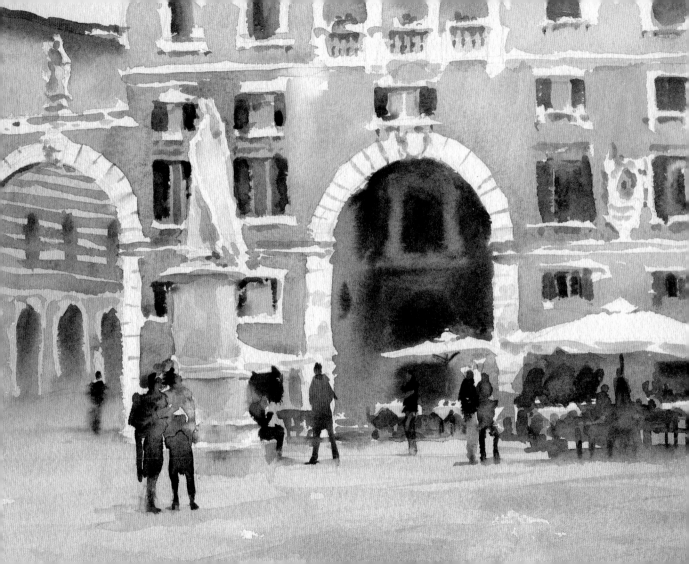

LEARN
WATERCOLOUR
QUICKLY

Hazel Soan

BATSFORD

Acknowledgements

Thank you to Kristy Richardson and Zoë Anspach for bringing this book into fruition. To Cathy Gosling for believing in me and to Tina Persaud for asking. To my husband John and son Sean, always many thanks for your support.

First published in the United Kingdom in 2014 by
B.T. Batsford
43 Great Ormond Street
London WC1N 3HZ

An imprint of B.T. Batsford Holdings Ltd

ISBN: 9781849941402

A CIP catalogue record for this book is available from the British Library.

25 24 23 22
10

Reproduction by Rival Colour Ltd, UK
Printed and bound by Leo Paper Products Ltd, China

This book can be ordered direct from the publisher at the website:
www.batsford.com, or try your local bookshop.

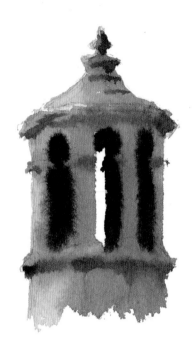

Previous page: **Piazza dei Signon, Verona** *(28 x 35.5cm / 11 x 14in)*

Contents

Introduction

I guess you picked up this book because you've always wanted to paint watercolours but haven't got much spare time. Or maybe you just like learning new things quickly. If so, this book is for you. You can read it from cover to cover in about 30 minutes and, before you reach the end, you will be ready to start painting.

▷ **Floating By**
(15 x 20cm / 6 x 8in)
Watercolour is a medium that can very quickly catch the essence of a subject.

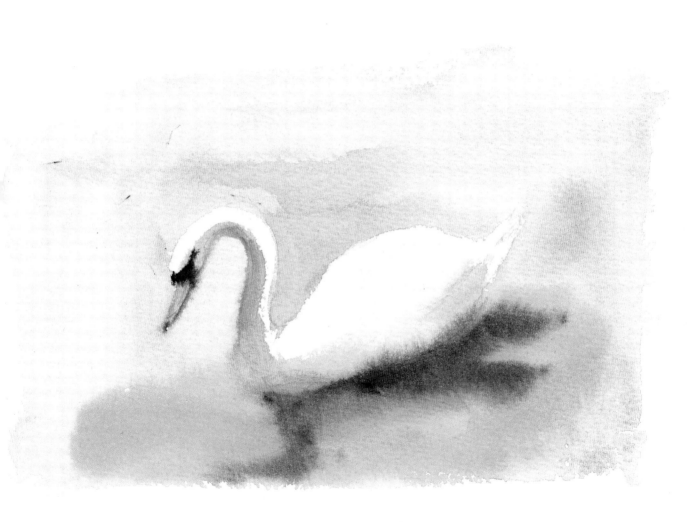

What you should know about watercolour

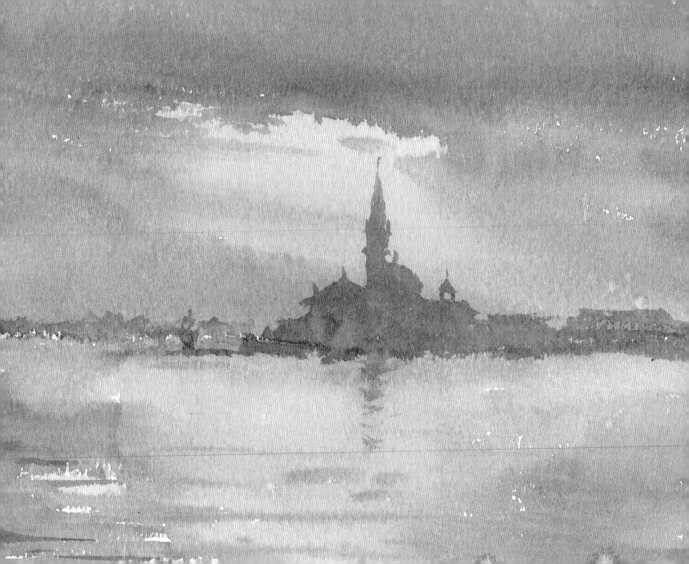

The medium of watercolour

Watercolour is a transparent painting medium that is diluted with water, mixed on a palette with a brush and then applied to paper. The light in a watercolour painting is represented by white paper, the painter paints the shade and tints the light. Watercolour paper is heavier than cartridge paper to prevent it from buckling when wet. You can use any tool to apply watercolour, but the brushes that are made especially for this medium make it much easier to get satisfying results.

◁ **Jewel of the Adriatic** *(28 x 38cm / 11 x 15in)*
With just two colours, light red and Ultramarine, the captivating medium of watercolour is able to evoke the glorious light of the rising sun over a majestic silhouette in Venice.

You need only the desire

Watercolour is known for its radiant washes and clarity of colour. The appearance of the watercolour is more important than the content it conveys – grasping this concept allows even a beginner to achieve attractive results. Always keep it in mind that you are using the subject to paint a watercolour rather than watercolour to paint the subject.

It is true that mastering watercolour to a high level of expertise will take time, even a lifetime, but the beauty of this medium can be found as soon as you start, just by letting the lovely pigments and papers do their stuff and not worrying too much or trying too hard.

▽ **The Student**
(28 x 36cm / 11 x 14in)

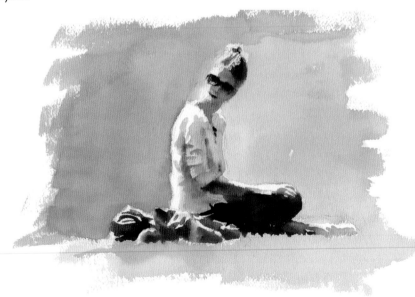

Be curious

Inquisitive people learn fast; art does have rules, but there are no boundaries. Here is a medium that benefits from thought before action and enjoys concentration. 'Less is more' should be the watercolourist's motto and being succinct often takes more preparation and care than being long-winded.

Do not be afraid to experiment even though you may waste paper in doing so, and don't be afraid to break the rules. Most great discoveries are made by mistake, so get out of your comfort zone and explore the medium. As much as is possible, paint from life rather than from photographs. Great pleasure is found in the process of painting and if you produce a worthwhile result, bliss will be your reward. The exciting thing about watercolour is that it actually does provide an adrenaline rush because of the precariousness that can be involved in using this medium.

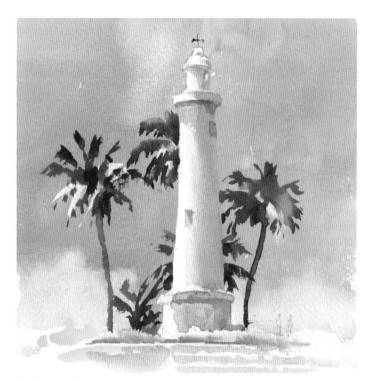

△ **The Lighthouse**
(25 x 25cm / 10 x 10in)

Creation and failure are interlinked

Creation and failure are inescapably linked: without doubt, among your successes there will be failed watercolours. These are part of your creative archive and are just as important as the paintings you come to cherish: get used to it, don't let it get you down, just carry on.

Watercolour can be unforgiving, but usually only when it is overworked and loses its fresh and lively appearance – as you haven't got much time, you are unlikely to fall into this trap! If it goes wrong it is only a piece of paper, so simply get a fresh piece and start again.

▷ **Crossing the Kalahari**
(23 x 30cm / 9 x 12in)
You need very few colours and little time to paint a watercolour. Here Ultramarine, Yellow Ochre and Permanent Rose are used in combination to create this desert scene in just a few minutes.

CHAPTER 2

The stuff you need

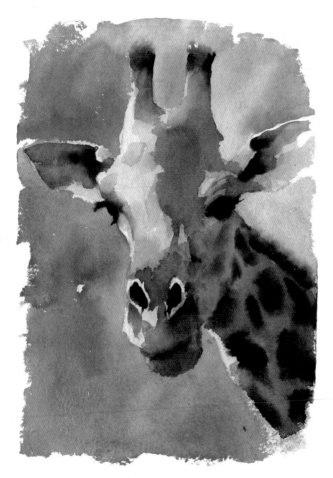

Less is more

You do not need many materials to paint good watercolours. 'Less is more' is the watercolourist's maxim and applies to the materials as well as the actual painting. Art shops can be overwhelming. All you need to start with is one fairly large or medium-sized sable brush, three to six tubes of paint, a palette to mix on, watercolour paper, water and some kitchen towel. If you want to work more upright, a lightweight, portable, folding easel is ideal as it can be carried outside. Alternatively, work flat; sit on a seat or stool and hold your painting on your knees or work at a table – you can't then tilt your paper in any direction.

◁ **Curious Giraffe** *(56 x 38cm / 22 x 15in)*
I worked flat to ensure the paint for the patches on the neck could spread out evenly in all directions.

Don't buy cheap products

Do yourself a favour: buy artists'-quality materials. These may be more expensive, but buying cheap watercolour paints is a false economy – it makes the painting process harder, and the paint doesn't go so far or bring such good results.

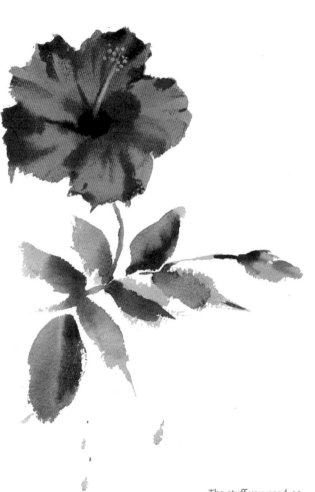

△ The purity and intensity of artists'-quality pigments make rich, glowing colours.

Brushes

Choose sable brushes, as they are easier to use than synthetic nylon brushes. Also, with sable you can manage with just one brush, whereas with nylon you would need several to make the same brushmarks. Start with one round sable brush – size 12, 10 or 8 depending on the size of paper you want to work on (see box, right). It will be more expensive than a nylon equivalent, but it is much more versatile, it will come to a fine point for detail and has a broad body that can carry lots of paint for larger washes, and it will last for many years. Research stockists online to find the best-value products.

If you want to add another brush at this stage, a 20mm (¾in) flat sable brush would be useful and costs less than a round brush. If you fall in love with this medium, you can add more brushes at a later date, including a thin, narrow brush for fine, even lines called a rigger.

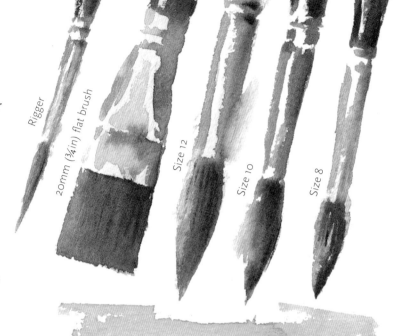

Rigger

20mm (¾in) flat brush

Size 12

Size 10

Size 8

Brush sizes
I suggest the following sizes of sable brush for particular paper sizes, but aim to use the biggest brush possible:
- Paper 51 x 41cm (20 x 16in) and larger: size 12 to 14 brush
- Paper 41 x 30cm (16 x 12in): size 10 brush
- Paper 30 x 20cm (12 x 8in) and smaller: size 8 brush

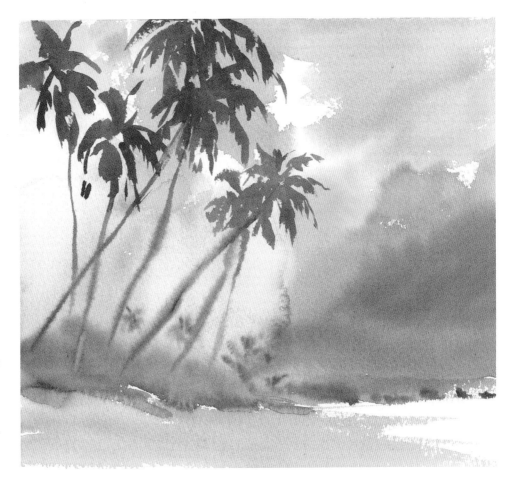

▷ **Bending to the Song of the Wind**
(25 x 28cm / 10 x 11in)
The sable brush can shape a frond or suggest a coming storm; the tip is used for detail, the body of the brush for broad washes.

Paints

Artists'-quality watercolour paints are purer and go a lot further than students'-quality colours and will make for more radiant paintings. With watercolour, the fewer colours you use, the better the results. Artists' watercolour is such an intense pigment that you need very little, and even a small tube lasts a long time. Since watercolour is essentially a transparent medium, you will be surprised at how little pigment you use for the majority of a painting (see page 42 for the colours I suggest you buy).

◁ This little sketch is painted with the same tube colours as shown in the picture: Ultramarine (blue), Alizarin Crimson and Aureolin (yellow).

Palette

When it comes to palettes, a china or enamel palette is easier to mix on than a plastic palette (but heavier to carry if working on location). A palette with several sloping wells is ideal so the water can pool at the bottom and remain drier up the slope.

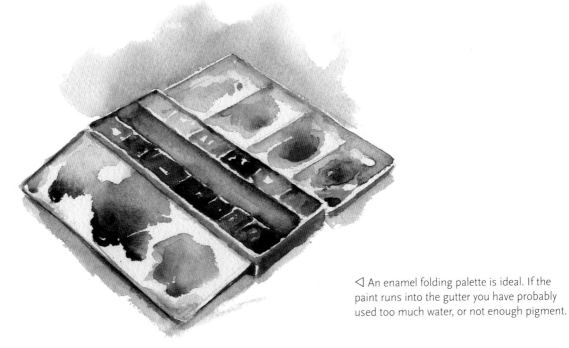

◁ An enamel folding palette is ideal. If the paint runs into the gutter you have probably used too much water, or not enough pigment.

Paper

The main ongoing cost in watercolour painting is that of the paper, but since you can only learn to paint by actually painting on the paper, it is rather essential!

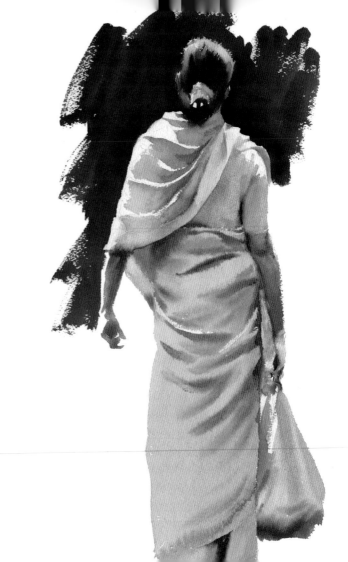

▷ **Lilac Sari** *(56 x 30cm / 22 x 12in)*
The uneven surface texture of watercolour paper gives pleasing edges to the brushmarks of the background in this painting as the paint dances over the rough grain.

There are two main types of watercolour paper: paper made with cotton and paper made from wood pulp. The paintings in this book are all made on 100 per cent cotton paper, mostly with a rough surface, so if you like their appearance I suggest you use the same. Later, you can experiment with different papers. Paper thickness is categorized by its weight per ream. Choose heavier weight paper – 300gsm (140lb) or thicker – forget thin paper as it buckles too much.

Surface texture
There are three main choices of surface texture:
• Rough: the grain has a prominent tooth.
• NOT (cold-pressed): the tooth is less pronounced.
• HP (hot-pressed): the surface is very smooth.

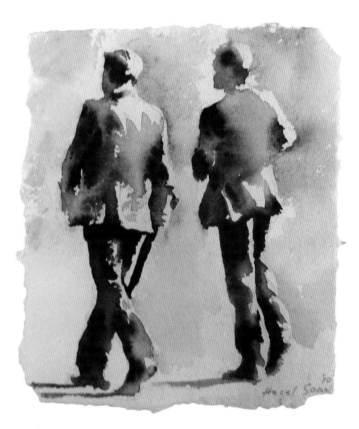

△ **City Duo** *(20 x 15cm / 8 x 6in)*
These city suits were painted on rough khadi paper, which is made with long-fibre cotton and therefore holds the water longer.

Water and kitchen towel

Water is needed to mix with the paint to break down the gum-arabic binder, thus allowing the paint to float on the paper and set when dry. It's a good plan to have two to three small pots of water – this allows you to use a couple for rinsing off paint and one clean-water pot for making the radiant tints. You will also need kitchen towel, a sponge or cotton rag to mop up excess water.

Pencil and eraser

It is not always necessary to draw before painting except when you need a guide for the brush. For this you need a softish pencil (2B or 4B) or a graphite stick. It does not matter if pencil marks show under a watercolour but, if corrections are to be made before painting, use a putty rubber rather than an ordinary eraser so that you do not scuff the surface of the paper.

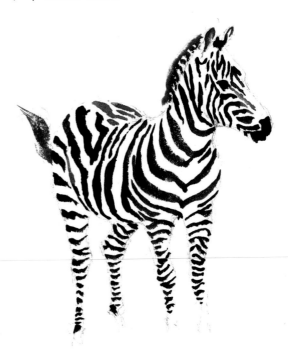

▷ Watercolours often require very little drawing before applying the paint. Here, only the outline of the zebra is sketched because the versatile sable brush can make specifically shaped strokes to delineate the stripes and thus shape the animal perfectly.

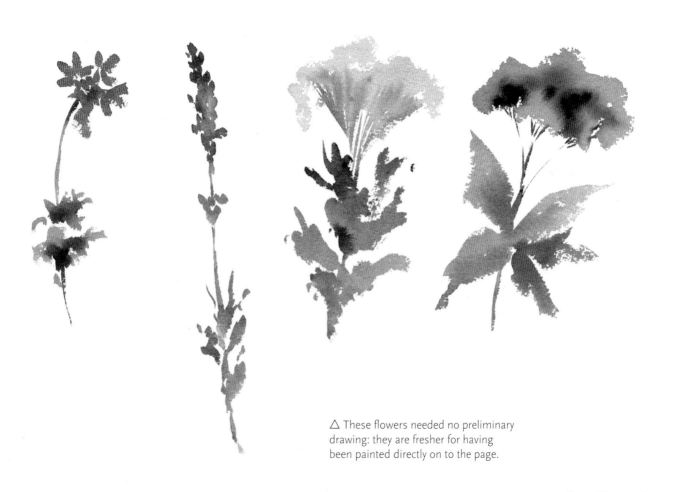

△ These flowers needed no preliminary
drawing: they are fresher for having
been painted directly on to the page.

Choosing the colours

The primary colours

There are three main colours in painting – red, yellow and blue. These are known as primary colours and can be mixed together to make all other colours. There are many different reds, yellows and blues available in watercolour, so it is possible to make many variations with combinations of a red, a yellow and a blue.

At the end of this chapter (see page 42), I recommend a set of colours to start painting with, but do aim to use as few as possible in any one painting.

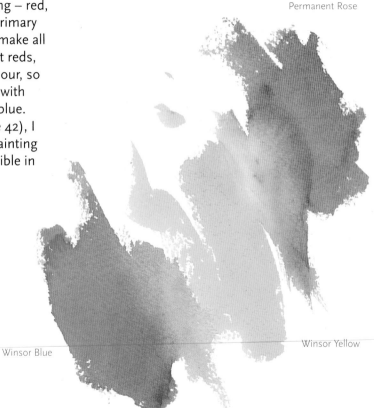

Permanent Rose

Winsor Blue

Winsor Yellow

▷ A blue, a yellow and a red mix to make a full range of colours.

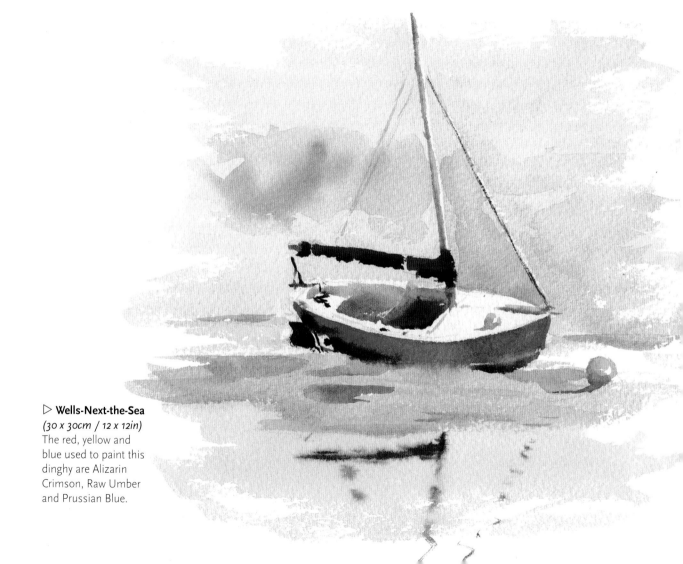

▷ **Wells-Next-the-Sea**
(30 x 30cm / 12 x 12in)
The red, yellow and
blue used to paint this
dinghy are Alizarin
Crimson, Raw Umber
and Prussian Blue.

Secondary colours

By mixing pairs of primary colours together you will make three more colours: these are called secondary colours. Red and yellow make orange, blue and yellow make green, and blue and red make violet.

△ Cobalt Blue and Permanent Rose make violet; here the colour is made by mixing the two together on the paper.

△ Blue and yellow make green; here the green is made by layering Winsor Yellow over Winsor Blue.

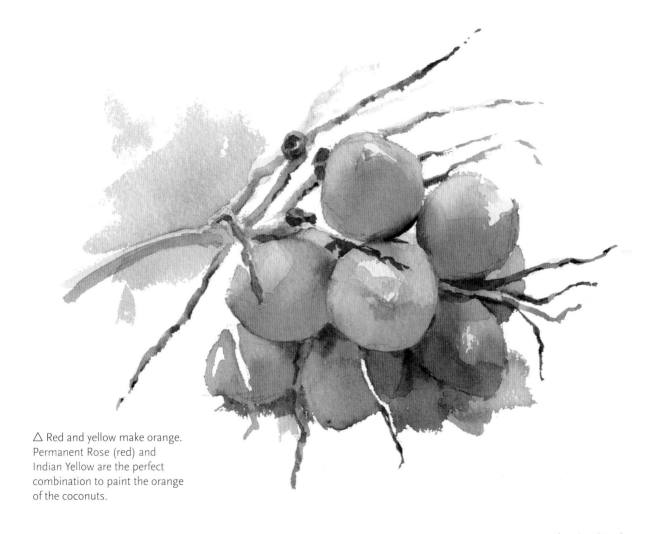

△ Red and yellow make orange. Permanent Rose (red) and Indian Yellow are the perfect combination to paint the orange of the coconuts.

Tertiary colours

When a primary colour (e.g. blue) is mixed with the secondary colour made from the other two primaries (e.g. orange, which is made from red and yellow), browns, greys and blacks result. These are called tertiary colours as they result from a third stage of mixing. Because watercolour paints come in a broad range of colours, mixing blacks, browns and greys can also be achieved by using ready-made secondary colours, such as Viridian (green) and Winsor Violet. Some examples of two colour combinations are shown on this page.

Over the page, in the watercolour of an elephant, you will see how layers of yellow, blue and red combine and mix together to make all the colours required for the painting.

Red and blue
(Cadmium Red
and Prussian Blue)

Red and green
(Permanent Rose
and Hooker's Green)

Blue and orange
(Ultramarine and
Warm Orange)

Green and red
(Viridian and
Permanent Rose)

Yellow and purple
(Aureolin and
Winsor Violet)

Green and red
(Permanent Sap
Green and Alizarin
Crimson)

▷ **The Sun Gets Up With Great Earliness**
(20 x 28cm / 8 x 11in)
The three colours used to make the greys in the sky and the black silhouettes in this dawn sketch on the river are Aureolin (yellow), Ultramarine (blue) and Burnt Sienna (a red-brown).

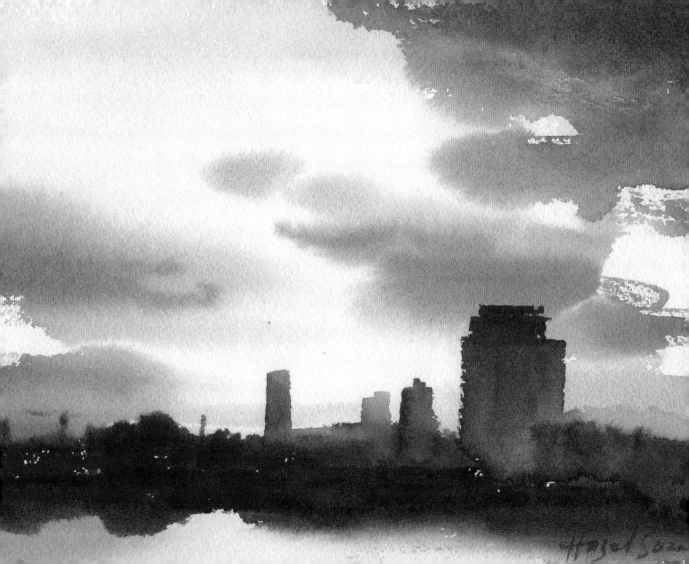

Stage 1: The first wash is the yellow of Aureolin, which goes under any colour that has yellow in it, i.e. any greens, oranges, browns and greys.

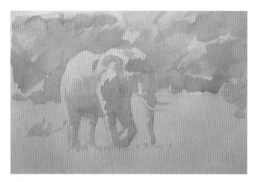

Stage 2: Prussian Blue follows, painting any area that has blue in it, such as the sky and the shadows and the green of the trees.

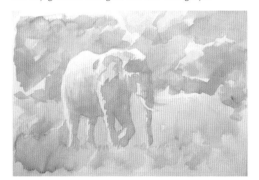

Stage 3: Now it's the turn of the red. Alizarin Crimson is diluted to a pale pink and goes over the yellow of the grass to turn it to orange and over the shadows on the elephant to turn them to grey.

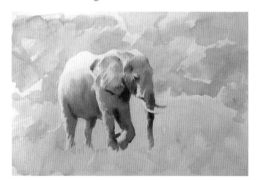

Stage 4: The same three colours are now used either individually or mixed together to darken the tones of the elephant and ...

▷ ... then in the trees to make the dark browns of the branches. So you see – with just three colours you can make a full range of colours and tones.

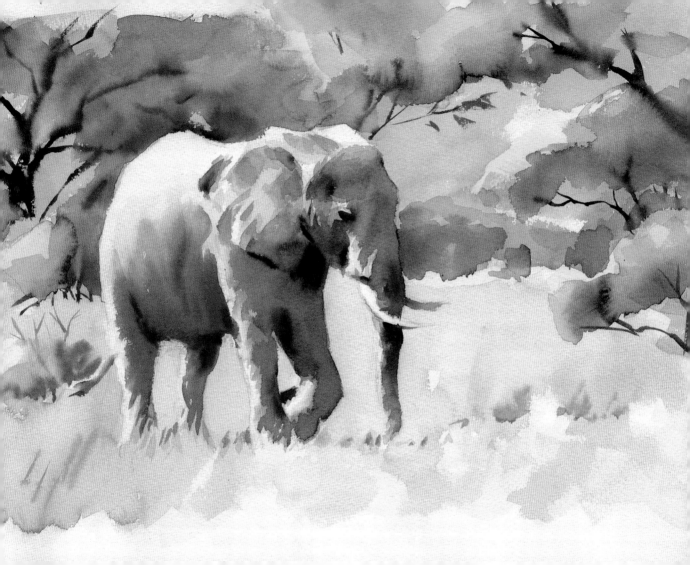

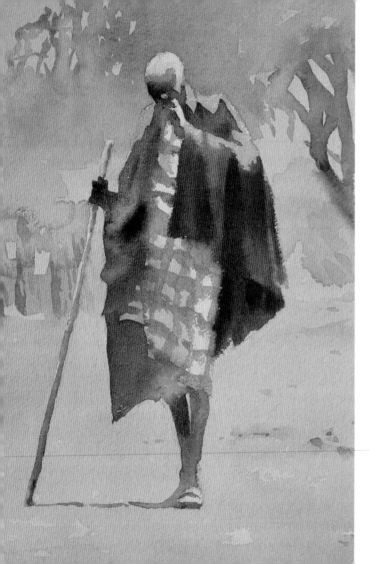

Transparency

The transparent, thin films of paint in watercolour are called tints and glazes. Because they are transparent, they can be overlapped to make an unlimited number of colours and shades. When diluted, all the colours are transparent, but in their concentrated form, some pigments are less transparent than others and some are actually opaque, providing a denser covering.

In a full palette you would need colours of all types, but, as it is often the misuse of opaque colours that causes muddy mixtures, to start with I suggest you use mainly transparent colours and add opaques for punches of bright or lighter colour instead of mixing with them.

◁ **Belonging** *(30 x 25cm / 12 x 10in)*
The reds used to paint the cloak and sarong of this Maasai chief are fully transparent pigments: Quinacridone Red with Brown Madder for the deep folds and shadows.

The fabric of the colours

Watercolour is made of the finely ground grains of real pigments; some of these are from the earth, some from carbon and some from metals and other minerals. The heavy metal cadmium gives us an opaque red, which is essential for its brilliant hue.

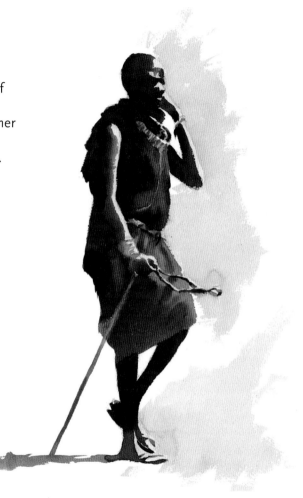

▷ Cadmium Red is used for the robe of this Maasai warrior – it is an opaque colour and delivers a bold, brilliant, dense red. You can see the difference compared to the transparent red opposite.

Colours have temperature

It may seem strange, but colours have temperature. Red is considered warm and blue is cold. The many variations in each hue also veer either to red or blue, giving us warm or cool versions of each colour. Artists call this the temperature bias and use it to alter the mood of a painting. Warm colours create a cheerful, upbeat mood; cool colours are more subtle and serious. Reds also jump forward, while blues recede.

In these two paintings, you can see how different the appearance of a warm blue and yellow appear as compared with a cool blue and yellow.

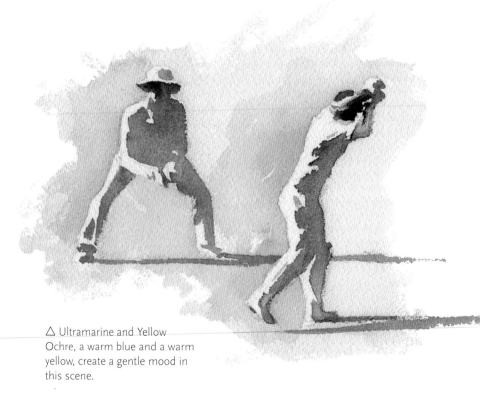

△ Ultramarine and Yellow Ochre, a warm blue and a warm yellow, create a gentle mood in this scene.

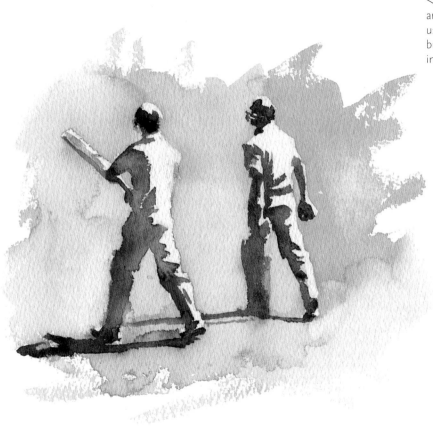

◁ Prussian Blue and Aureolin are the cool blue and cool yellow used here. The effect is brighter but more 'severe' than the warmer image shown opposite.

Your first set of colours

When you choose a set of colours, ideally you want to include both a warm and a cool version of each of the three primaries – red, yellow and blue – and then you can indeed mix all the colours in an infinite number of ways. This collection of eleven colours is a great starter set.

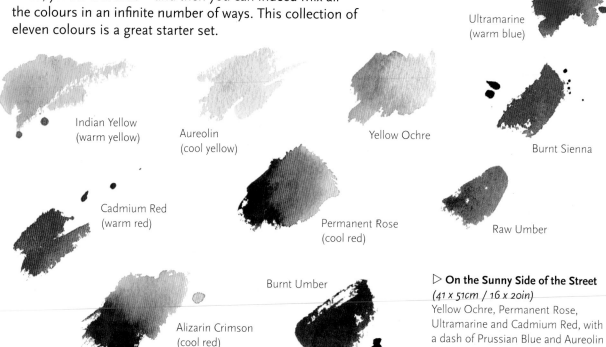

Prussian Blue
(cool blue)

Ultramarine
(warm blue)

Indian Yellow
(warm yellow)

Aureolin
(cool yellow)

Yellow Ochre

Burnt Sienna

Cadmium Red
(warm red)

Permanent Rose
(cool red)

Raw Umber

Burnt Umber

Alizarin Crimson
(cool red)

▷ **On the Sunny Side of the Street**
(41 x 51cm / 16 x 20in)
Yellow Ochre, Permanent Rose, Ultramarine and Cadmium Red, with a dash of Prussian Blue and Aureolin for the bright greens.

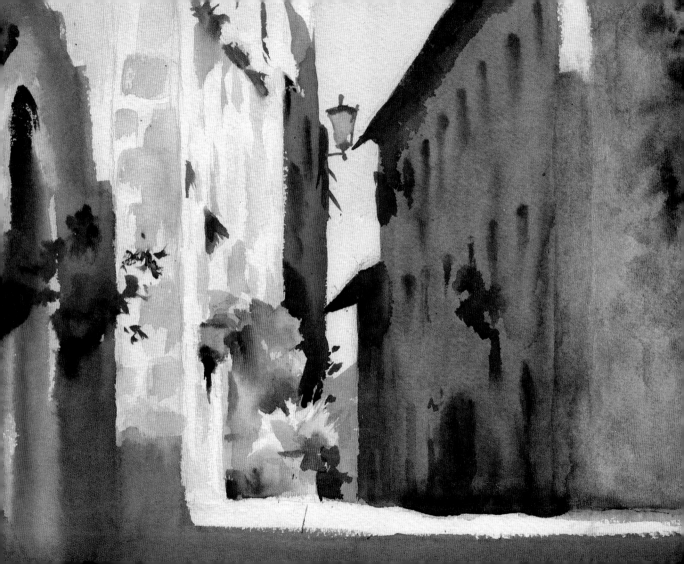

Putting paint on paper

Mixing on a palette

The idea of mixing paint on a palette is to get it to the right colour, consistency and quantity before loading the brush for the strokes ahead.

If you are using tubes of paint, squeeze just a little on to the palette. Don't put it in the middle, as this is where you will be mixing; place it at the edge or up the slope of the palette. Dip your brush in the water pot and fully load it with water, then tap off the excess on the side of the pot. Touch the tip of the brush into the edge of the squeezed-out paint to pick up a small amount of pigment and then mix it on the palette in a circular motion to create an even consistency.

If you are using watercolour pans, work the wet brush on the dry pan until it yields sufficient colour, then bring it on to the palette to mix evenly.

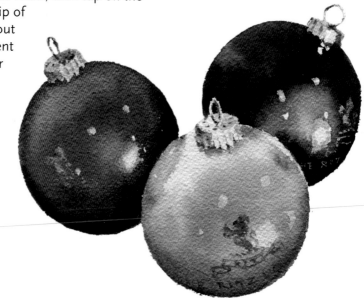

▷ Look carefully at these Christmas baubles to see how the colour on each has been diluted to make the lighter areas, and deepened to paint the shaded areas. Differing amounts of water are needed to reach each consistency.

The right amount of water

The more water you use, the more dilute the paint will become.
Avoid using too much – if it all runs into the gutter of the palette,
instead of a sparkling glaze you will only have tinted water!

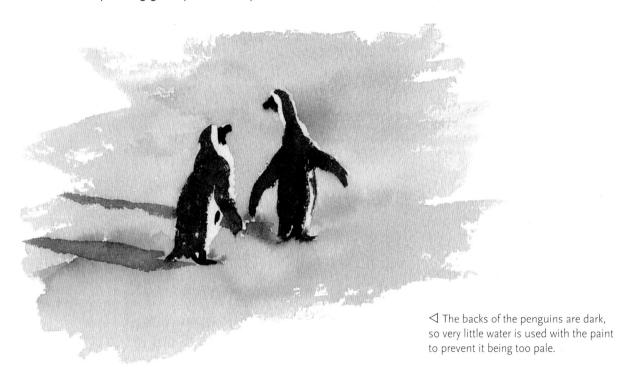

◁ The backs of the penguins are dark,
so very little water is used with the paint
to prevent it being too pale.

The brushmarks

Watercolours are painted with brushstrokes that join up, overlap and stand alone. The secret is to use as few strokes as possible to give the most information. Individual brush strokes, shown right, join to make the hockey players below. Once again, less is more. Learning to use the brush with dexterity will bring early success to your paintings.

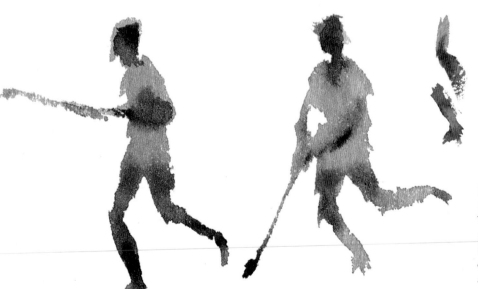

▷ **Lovely Weather for Ducks**
(20 x 28cm / 8 x 11in)
The shapes of the ducks are painted with quite precise brushstrokes; the ripples, on the other hand, are freely applied, along with the broad washes that tint the water.

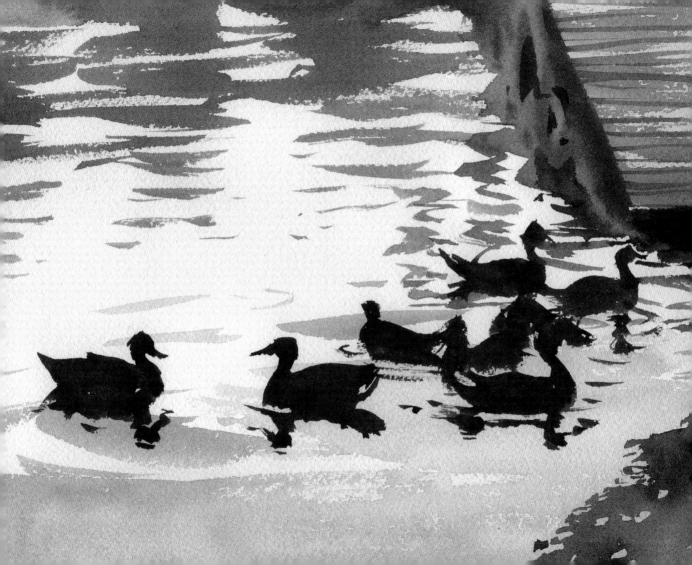

Using the brush

The tip and body of the round sable brush enable you to make brushmarks in any number of shapes and sizes. Intricate shapes, fine details and broad patches can all be made with a loaded brush. Hold the handle of the brush with your thumb and forefingers around the fattest part. In this position, you will get free but controlled movement at the brush head. Use the tip to make fine marks and lines, and press down the body of the brush to make broader marks. Get used to rolling the brush handle between your fingertips so you can twist and turn the brush to make marks for specific shapes.

▷ Pressing the brush down releases more paint to make the broad petal shapes. Using just the tip draws the narrow lines. Dabbing in touches of yellow paint with the tip of the brush indicates the stamens.

△ To make these leaf shapes, bring the tip of the brush to a point by rolling it in the palette; hold the brush at an angle to the paper as you make the stroke – press down to release more paint in the middle of the leaf, twist it again to bring it back to a point, and lift off at the end of the leaf.

△ To make more complex shapes like these red leaves, the brushstrokes are joined up: the wet paint from each stroke blends together to make a seamless shape.

Try the flat brush too

The flat sable brush is a versatile tool that allows for panels of colour, broad strokes and also narrow lines. You can lay washes and make marks of almost any shape and size. All the marks on this page are made with a 20mm (¾in) flat brush.

▷ **Dawn Rush Hour on the Grand Canal** *(36 x 51cm / 14 x 20in)* This painting of Venice is painted entirely with a flat brush. The large brush head is great for keeping your approach loose and bold.

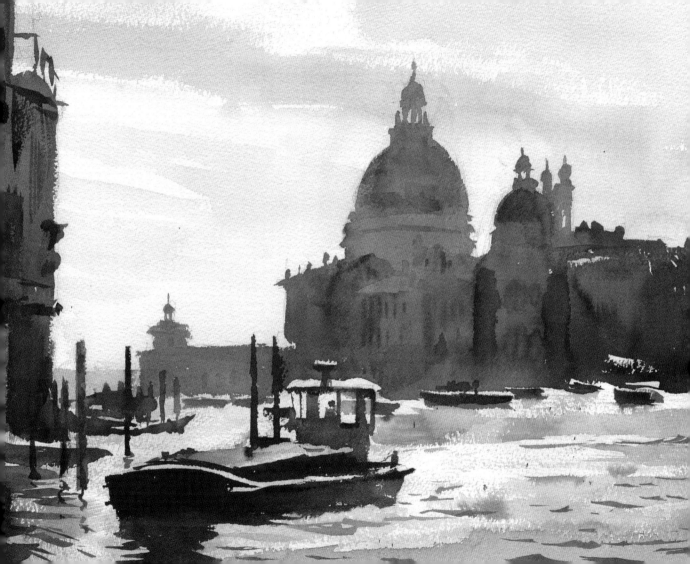

Painting techniques

There are three main techniques for applying paint to paper in watercolour and each has a rather obvious name: wet on dry, wet into wet, and dry-brushing. The next few pages explain these techniques and also show you how to make seamless washes for large areas of colour such as skies.

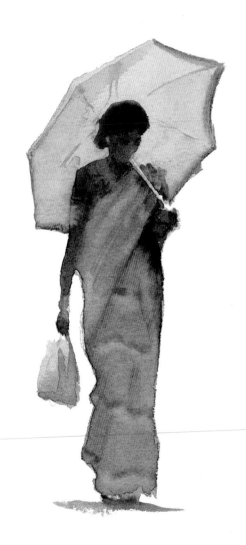

▷ **Lady in Red** *(18 x 8cm / 7 x 3in)*
The border and fine lines on the umbrella are added into the wet wash with dry brushstrokes.

▷ ▷ **Passionate About Pink**
(28 x 35.5cm / 11 x 14in)
Two of the main techniques used in watercolour can be clearly seen here in the petals of the bougainvillea: wet-on-dry layering and wet-into-wet blending.

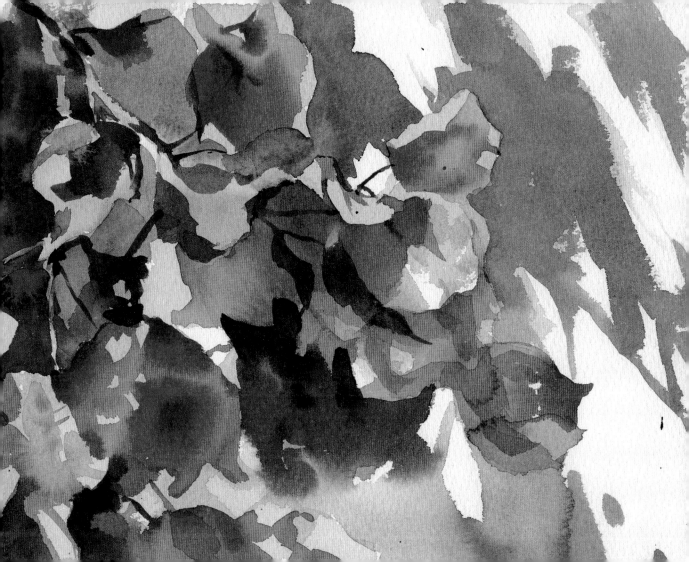

Wet on dry

In this technique, the wet paint is applied to dry paper, giving a crisp edge to the laid brushstroke. When dry, subsequent layers of transparent colour can be added on top in a series of overlapping tints and glazes. Because watercolour is a transparent medium, this layering of colours creates a whole variety of new colours and tones from just a few pigments.

To avoid disturbing the drying particles of pigment underneath, each layer of paint must be allowed to dry completely before the next is added.

◁ The transparent tint of Ultramarine over the pink of Permanent Rose makes a charming violet; laying Indian Yellow over the same pink makes a vibrant, translucent orange.

▷ **Dallas Skyline** *(28 x 35.5cm / 11 x 14in)*
Working wet on dry is ideal for suggesting angular forms such as the skyscrapers in this city, as it clearly defines the edges to the washes and brushstrokes.

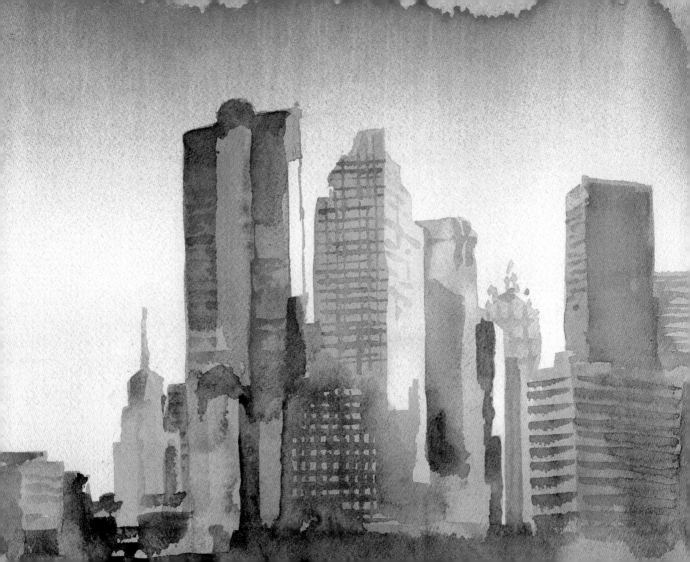

Mixing by layering

The colours created by layering vary according to the order in which the colours are laid. Even from the same two colours, the result will differ depending on which colour is laid first. Since each mix is unlikely to be exactly the same as the one before, these differing tones add to the endless variety you can achieve.

Layering is used frequently in watercolour landscapes. The sky is painted first and is often extended under the foreground features to provide an undertone, which encourages harmony in the painting and enhances the mood. Sky washes must be allowed to dry if a crisp skyline is required.

▷ When colours are overlapped, the colour looks different depending on which colour is on top. On the left, Yellow Ochre is laid over Ultramarine and on the right, Ultramarine is laid over Yellow Ochre.

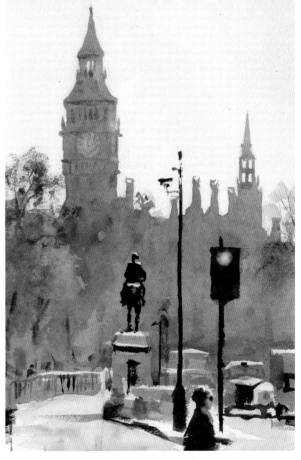

London Calling *(56 x 38cm / 22 x 15in)*
Stage 1: The pale sky wash of Yellow Ochre and Prussian Blue is painted as an undertone to the whole painting.

Stage 2: The London skyline is only added when the wash for the sky has dried. The yellow undertone shimmers through the grey mix laid on top.

Wet into wet

In this technique the paint is applied to paper that has been either dampened with clean water or is damp from a previous, still-wet wash or brushmark. Paint is introduced with a gentle stroke and spreads out into the damp surface or wash, giving soft edges to the brushmark and creating gradual blends where wet colours mingle with each other. Successive applications of paint must each be more concentrated than the last to take into account that there is already water on the paper from the previous wash. The drier the colour, the less it will spread.

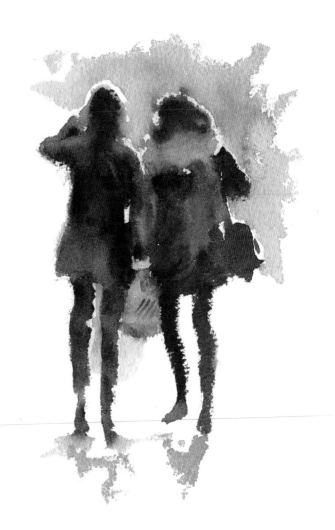

▷ **Retail Therapy** *(25 x 15cm / 10 x 6in)*
The girls in this sketch would look rather static if their details were clearly defined. By adding the colours wet into wet, the pigments blend into one another and the watercolour appears more lively.

▷ ▷ **Spring is Sprung** *(20 x 28cm / 8 x 11in)*
The yellows of the daffodils are gradually deepened by adding more concentrated (and therefore drier) colour, wet into wet. This technique is ideal for painting organic subjects such as flowers.

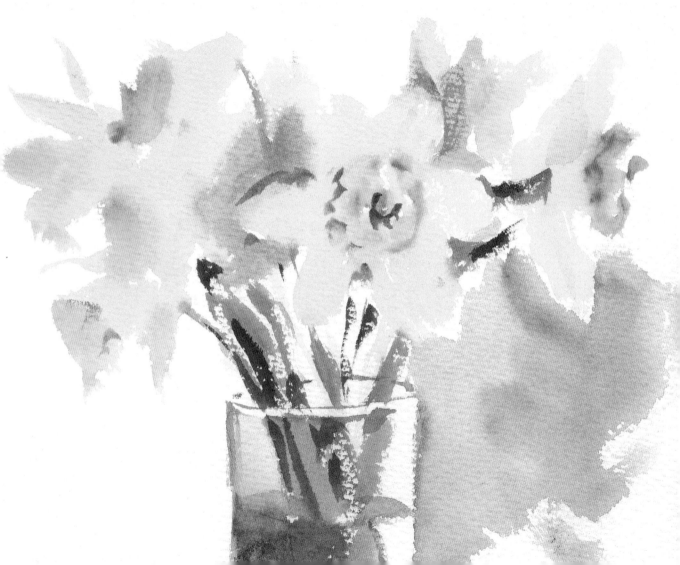

Mixing on paper / blending on paper

With a wet-into-wet technique a touch of ambiguity is created as the colours blend together on the paper more freely than when they are applied with wet-on-dry brushstrokes.

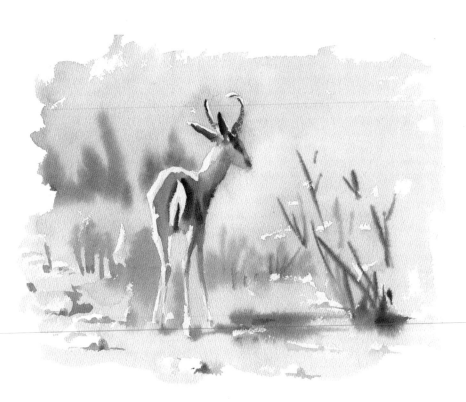

◁ **Springbok**
(20 x 28cm / 8 x 11in)
The scrubby foliage is dashed into the background with energetic brushstrokes while the wash is still wet, suggesting more interesting foliage than if it had been applied with regular wet-on-dry brushstrokes.

Back-runs

If the mix of paint in the added brushstroke is too wet, the water will flow into the previous wash and cause a back-run, a mark that resembles a cauliflower! Watery paint that pools in a wash can be sucked up with the tip of the brush. However, don't be afraid of back-runs: they are one of the lovely characteristics of watercolour and although they may happen by mistake, they can also be used purposefully.

▷ **Giraffe** *(38 x 28cm / 15 x 11in)*
An attractive suggestion of dust kicked up by the giraffe is created by engineering a back-run.

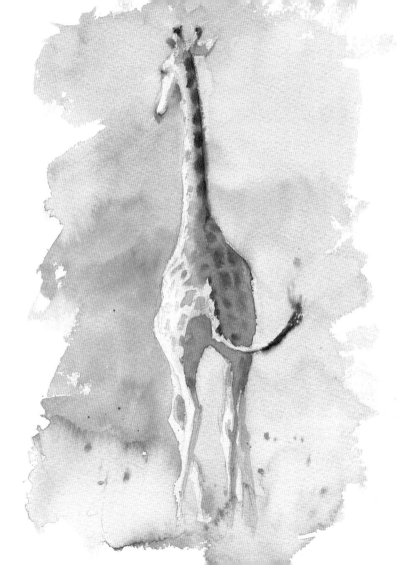

Working at speed

Adding colours wet into wet is a technique for speed as you do not have to wait for paint to dry. The rich dark tones of this elephant walking through the bush are quickly arrived at by painting wet into wet.

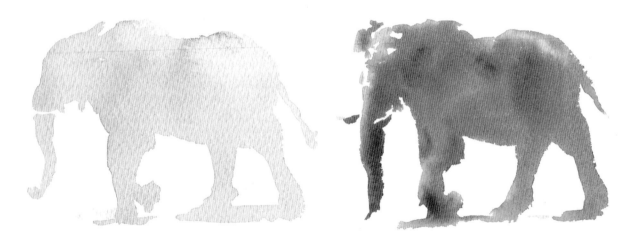

Stage 1: First the shape is painted with a pale wash of Quinachridone Gold.

Stage 2: Next Quinachridone Red is added, leaving the lighter topmost parts untouched.

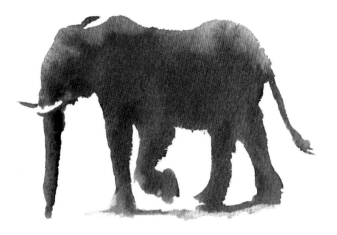

Scan to watch an online demonstration of Hazel painting this elephant.

Stage 3: Then Indanthrene Blue is touched in, leaving more of the top-lit area untouched. The colours have blended together to make a warm purple grey.

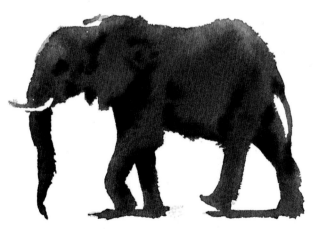

Stage 4: Lastly a neat consistency of all three colours is mixed together in the palette to make a black and touched in from the shadiest sides to give some definition.

Dry-brush

The neat paint applied by a dry brushstroke provides a certain energy, as the action of the stroke is visible. The paint is not always concentrated – sometimes the brush is just barely loaded with paint and brushed sideways across the surface of the paper to create an uneven wash or brushstroke.

▷ The brush is loaded with concentrated paint and applied with vigour to the paper.

△ Dry brush is more effective on a rough paper as the brush deposits paint on the bumps and skips over the troughs, leaving an attractive broken texture.

Splaying hairs

Pinching the hairs of the brush between your fingers and splaying them apart makes each hair deliver its load of paint in a single strand. You can use this method to make a series of fine lines. Hot-pressed or NOT paper is better for this technique.

▽ The patina of wood is created by splaying the hairs of the brush as it is brushed over a background wash.

Other useful techniques

Paint can be applied with any tool, even your fingers. Artists often use sponges to apply watercolour to make a speckled patina, or splatter paint from the brush to make attractive random splashes, or even spring it from a toothbrush to make a fine-grained splatter.

▽ **Spatter**
Paint is flicked from a brush to give the random impression of footsteps along a beach.

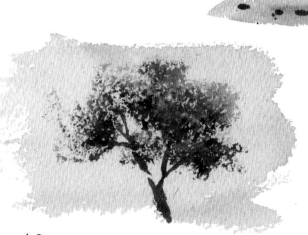

△ **Sponge**
This pattern of speckled foliage is achieved by applying paint with a natural sponge.

△ **Splatter**
Running your finger backwards across a toothbrush loaded with paint releases a fine spray of paint, ideal for representing a gravelly texture.

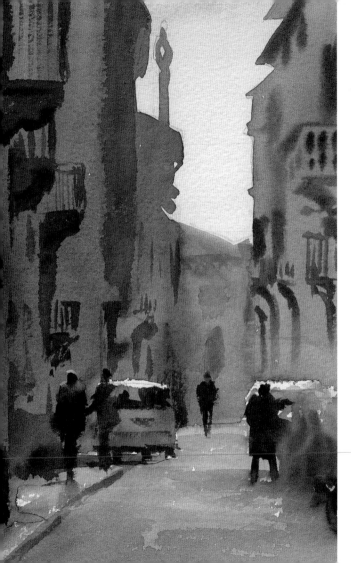

Reserving the white paper

In watercolour, the white of the paper represents the light, so it is a very important factor in a painting. The watercolourist leaves highlit areas untouched, tints light areas and paints the shade, usually building from light to dark tones. As a result, watercolourists rarely need white paint, except to add small details of light, or to correct small areas, or to mute strong colours.

Drawing a pencil sketch to mark the lightest areas of your subject before you start painting provides a guide for the brush, telling it where it can and cannot go.

◁ **Living Streets, Verona**
(28 x 20cm / 11 x 8in)
A pencil guide enabled me to brush in the buildings' shapes with confidence and leave out the highlights on the roofs of the cars.

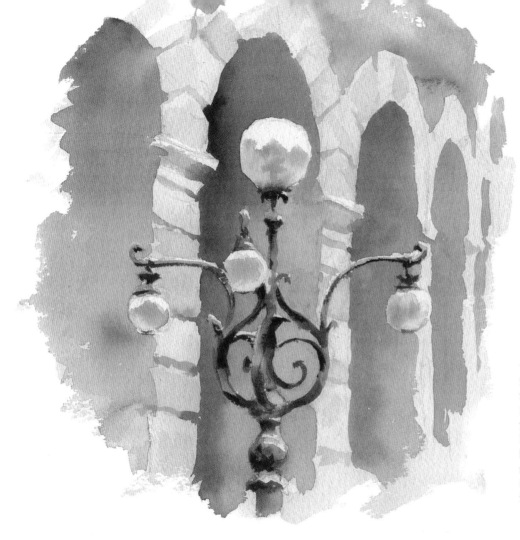

◁ When a subject in the foreground is lighter than the background, like these lamps against the arches of the arena in Verona, a pencil guide helps to paint the wash safely around it and reserve highlights on the framework of the lamp.

Masking fluid

Art suppliers sell a useful aid for reserving fiddly areas of light: a pale-coloured latex liquid called masking fluid. It is applied to areas you want to preserve as highlights, painted over when dry, and then rubbed off when the paint itself is dry to reveal the untouched paper.

Warning: Never use your best brushes to apply this fluid, as it ruins brushes as soon as it dries. Use a cheap brush or an old, worn-out brush, the end of a brush or a dip pen.

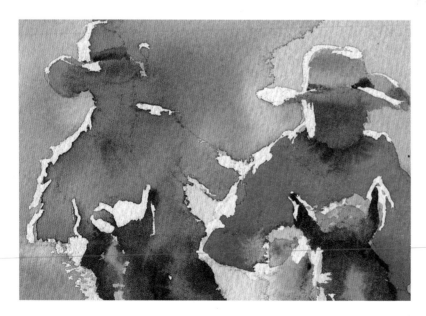

▷ **Texas Rodeo**
(30.5 x 40.5cm / 12 x 16in)
Masking fluid has been used to reserve the highlights and the swish of the reins in this glimpse of rodeo action.

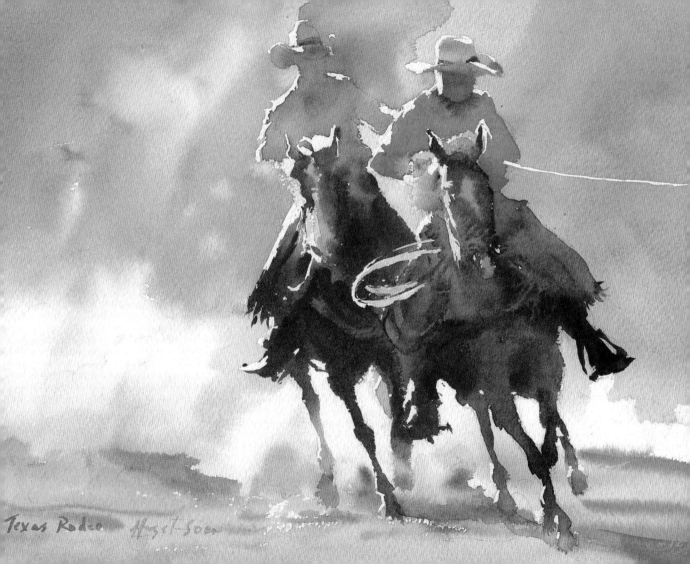

Texas Rodeo

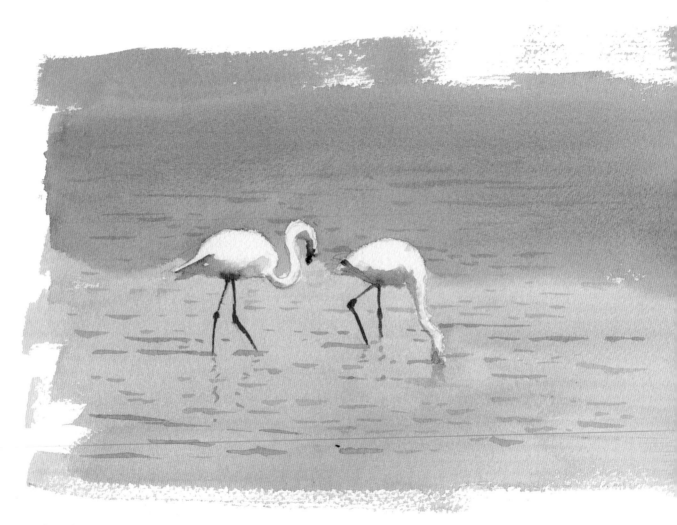

Washes

Large areas of a colour or a blend of colours are achieved by laying broad, overlapping, brushstrokes, and allowing them to blend together seamlessly. This is called a wash.

The first wash is the freshest

Even though many watercolours are built up in layers, watercolour marks are by default at their most transparent in a single film, so try to make your initial washes in a single, seamless layer.

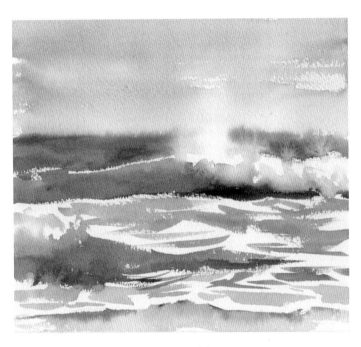

◁ **Duet** *(28 x 35.5cm / 11 x 14in)*
Ultramarine has been painted in broad, overlapping brushstrokes made with a flat brush to create a smooth background wash for the water surrounding the flamingos.

△ **The Green Sea** *(25.5 x 28cm / 10 x 11in)*
This painting is created from top to bottom with narrow, linear washes of single layers of pigment. White paper is left between brushmarks within the washes, creating a vigour in the painting.

How to paint a wash

Load your brush with paint (use either a round or flat brush). Brush it across from one direction, gradually coming down the paper and letting each subsequent stroke slightly overlap the previous one so that the brushstrokes blend along their length. Continue until the required area is covered. Try to resist taking the brush back and forth like a house-painting brush: the freshest wash is the one in which the particles of paint are allowed to dry undisturbed. Don't fiddle with the wash while it is drying either – any aberrations are unlikely to be noticeable once the rest of the painting is in place.

Lift any pooled water out with the tip of the brush or the corner of a piece of kitchen towel so as not to disturb the drying wash. Do not dab: it will spoil the appearance.

If the area of the wash is dampened first with a clean, damp brush, it helps the wash to blend more easily on the paper and provides a more even effect.

Graduated wash

A graduated wash is one that varies in tone from top to bottom. To make a wash that gets lighter towards the bottom, such as you might need for a sky, allow the natural offloading of the pigment to lighten the colour for you or gradually dilute the paint as you come down the page.

△ Lay it and leave it – a happy wash is painted and left well alone.

△ If you mess with a wash you will disturb the drying paint and lose the freshness.

△ If you allow paint to pool in the corners it will back up and cause a backrun.

Variegated wash

A wash of more than one colour is one of the most attractive passages of colour in watercolour. This is called a variegated wash. Dampen the paper before you start; it will encourage the colours to blend together and create a seamless wash.

The Dragon Soon Sleeps, Sri Lanka
(20 x 28cm / 8 x 11in)
The colours blend on the damp paper to evoke the soft, dusky glow of the humid equatorial sunset.

Drifting wash

Gravity is your friend when you want to make colours drift into or through a wash. Tilt the paper to encourage the flow of paint and lay it flat as soon as you have achieved the desired effect.

▷ Wet the paper before applying the paint. Tilt the paper in the desired direction and allow the paint to drift into position.

▷ ▷ The drifting blends of watercolour create an evocative atmosphere as a shaft of light parts the clouds above this beach.

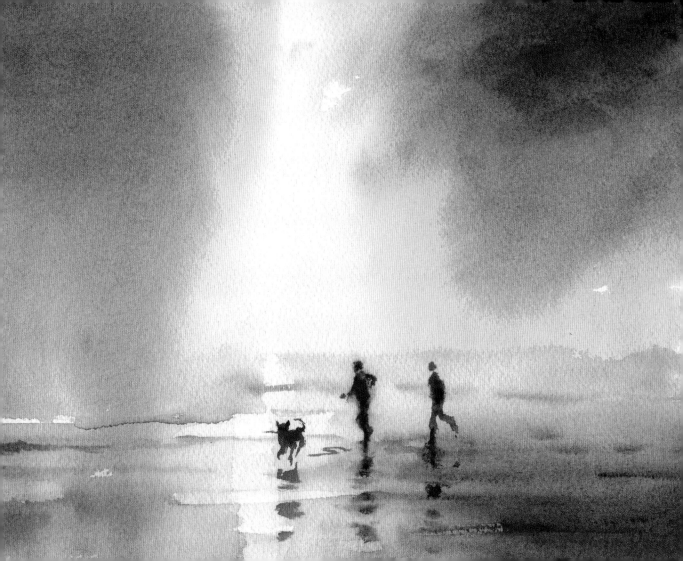

Restoring light in watercolour

The aim, in watercolour painting, is to keep the painting as fresh as possible. If you overwork washes they lose their transparency, which cannot usually be regained, and it is often quicker to start again rather than try to correct; however, small corrections can be made and highlights added with white watercolour paint because it is opaque.

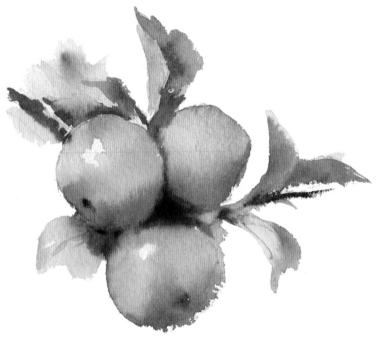

White paint

In watercolour, white paint cannot replicate the white paper, but it can be used to regain highlights in small areas and especially if positioned amid darker tones.

△ The highlight on the lower apple has been restored with white paint and looks almost as fresh as the untouched white paper highlight on the apple above.

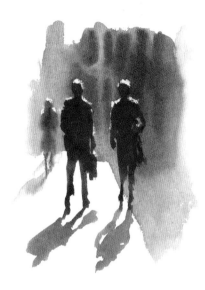

△ White paint has been used to restore the highlights on the figures and stands out well against the dark background.

▷ **Homage to Winslow Homer**
(76 x 56cm / 30 x 22in)
Several highlights on the coconuts are restored with white paint, some of which is tinted with an Indian Yellow glaze to re-create the orange glow.

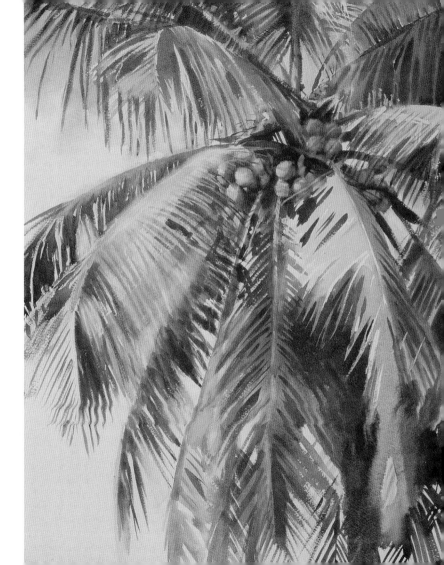

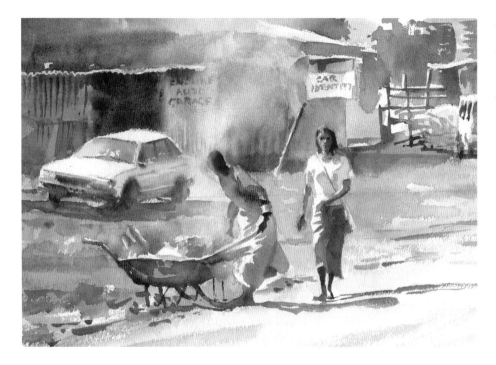

◁ **Kenyan Wheelbarrow**
(30 x 41cm / 12 x 16in)
The smoke is created by lifting off the Ultramarine paint of the background with a clean, damp sponge.

Lifting off

There are some pigments that are called 'lifting colours' because they do not stain the paper. They can be lifted off with a clean, damp brush or sponge even when completely dry. Useful examples are Ultramarine, Burnt Sienna and Burnt Umber.

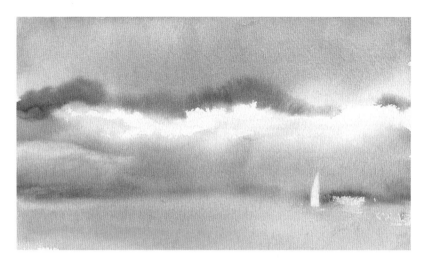

(28 x 38cm / 11 x 15in)
The colours used here are Ultramarine and Burnt Sienna, both 'lifting colours'. The white sail has been lifted off with a sponge wiped between a stencil cut to the shape of the boat, then dabbed dry.

Scratching off

Because watercolour paper is thick and fairly robust, you can scratch the paint off small areas of a finished painting with a sharp blade to reveal the white paper.

▷ A scalpel blade is drawn across the surface of the paper to scratch out the ripples on the water.

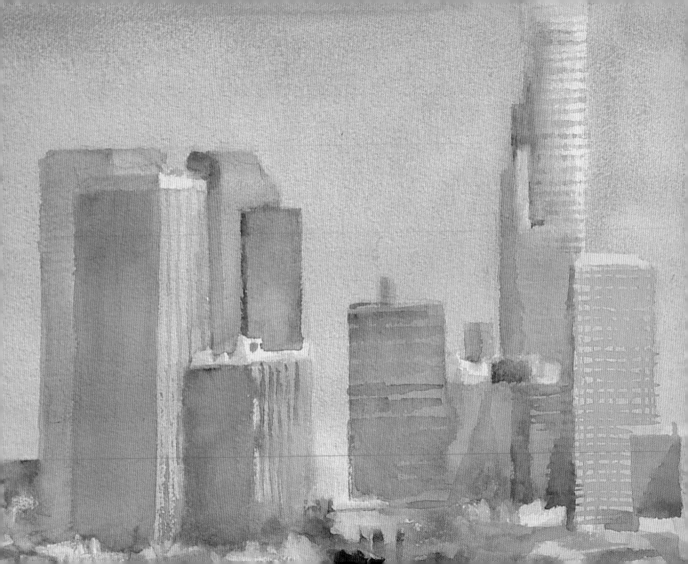

Selecting a subject

What makes a good subject?

Representational watercolour painting makes a pattern of colours work together on flat paper to suggest, or look like, something that exists in three-dimensional form in the real world.

The artist has a set of tools at his or her disposal in order to achieve this – line, shape, light and shade (known in 'art-speak' as tone or value), perspective, proportion and colour. A picturesque view does not necessarily make a good painting unless there is a convincing pattern of light and shade going on, or an interesting composition of shapes and lines. Likewise, a mundane subject can turn into a marvellous painting when blessed with a light that turns it into an attractive design of light and shade.

Things to look for
- **Lines** that lead the eye into the painting or towards the focus
- **Shapes** that vary and make interesting brushmarks
- **Light** that enlivens and breaks up areas of darkness
- **Shade** that suggests form, offers a touch of ambiguity and provides areas of peace
- **Perspective** to imply depth, distance and narrative
- **Proportion** to enhance scale and a sense of space
- **Colour** that entertains the eye

▷ **Rainy Day in Verona** *(20 x 23cm / 8 x 9in)*
A dull, wet afternoon springs to life with the contrasting shapes of dark figures and their brollies, thus making an interesting pattern of light and shade and a good subject for a painting.

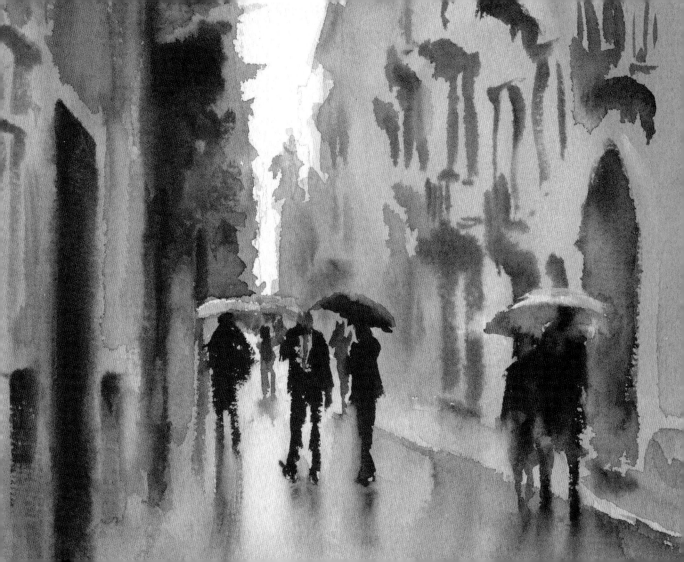

Shape

Shape is hugely important to painting watercolour: intriguing shapes will captivate your audience and entertain the eye. An interesting or arresting shape is always a good subject. The shape delineates the space of an object and enlivens the surrounding area. When painting a shape, avoid presumption and generalization, and take advantage of the irregularities and intricacies of the outline to make sure you have maximized the entertainment value.

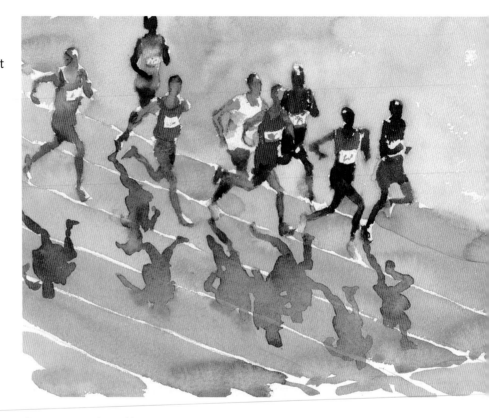

△ **Prospecting for Gold** *(28 x 38cm /11 x 15in)*
The runners and their reflections all enjoy slightly different shapes as they sprint for home, making them a lively subject for watercolour.

Silhouette

Against the light, shapes fall into silhouette and become easier for the watercolourist to paint. Being darker than their surroundings, they can be painted without drawing first and with positive brushstrokes. As always, take care to seek out the essence of the shape.

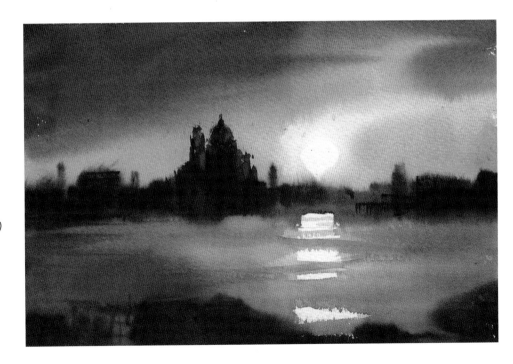

▷ **Lagoon**
(20 x 28cm / 8 x 11in)
When a complex building like Santa Maria della Salute in Venice falls into silhouette against the setting sun, it becomes much less daunting to paint.

Negative spaces

The eye orientates itself to that which is tangible, but the spaces between and around objects are just as important and interesting to the flat world of painting. These areas are often termed the negative spaces.

Because you are painting on a flat surface with transparent colours, the background and foreground are not really separate things; they get built up together. Get used to thinking of them in conjunction with each other. For example, a background might be needed to show up the light on the side of a subject, because without a background the light could not be seen, so it is painted along with the subject.

◁ The spaces around and between things are also termed negative shapes.

▷ **Freedom of the City**
(20 x 28cm / 8 x 11in)
The spaces under the arches, the gaps between the figures and the haloes of light over their heads are just as interesting as the silhouettes themselves – maybe more interesting.

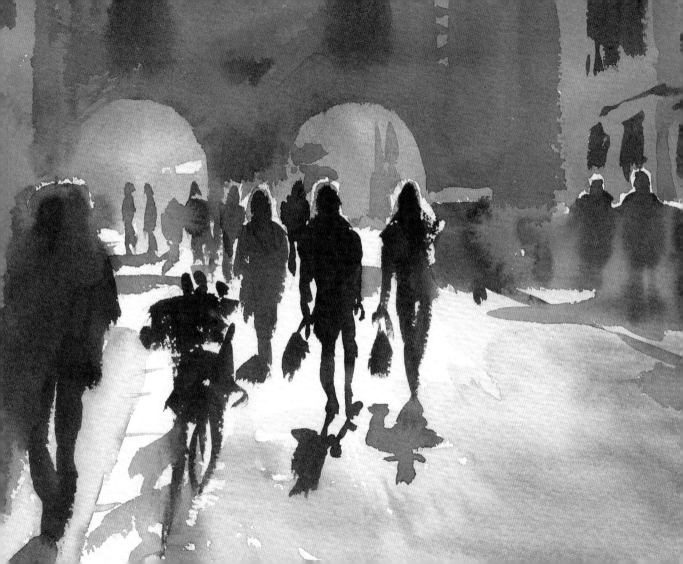

Light and shade

Strong light and shade make exciting watercolours, and so too does subtlety. Light and shade announce form, depth and space and in a painting these are interesting allusions. An object will be lighter on the lit side and darker on the shady side even if it is of one colour in 'real life'. This variation in tone over the surface of objects is delightful to paint and persuades the viewer of the shape of the subject being represented.

Stage 1: A sunny subject can be composed by painting just the areas in shade with a blue. Immediately, the structure is obvious because in painting the shade you thereby established the forms.

Stage 2: The colours of the painting are laid in glazes over the blue shadows, which remain visible below the transparent layers, reinforcing the structure of the painting.

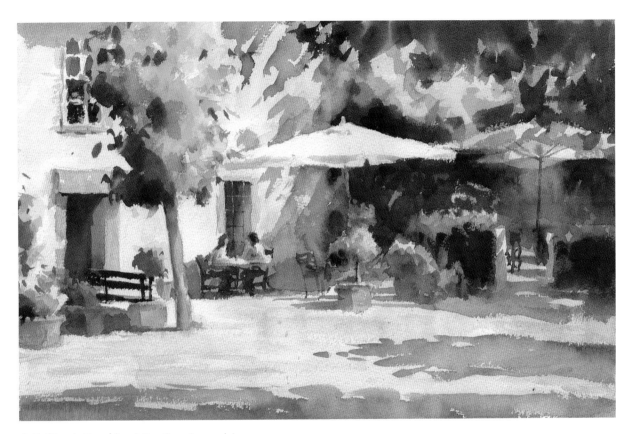

△ **Bathing in Sunshine** *(38 x 56cm / 15 x 22in)*
The darkest areas are strengthened in tone and details added in, always maintaining
the same counterchange of light and shade established from the start.

Form

The changing shade of a colour around
a form is always an interesting subject to
paint. To demonstrate three-dimensional
form in painting use a light tone, mid-tone
and dark tone.

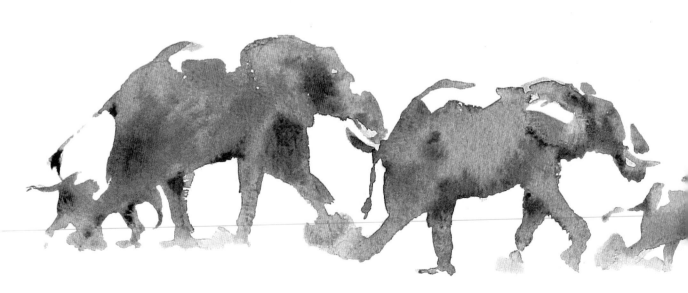

▽ **Line of Intent** *(10 x 50cm / 4 x 20in)*
The lightest tone is the highlight on the
backs of the elephants, showing us that
these face upward towards the sun. The
mid-tone is the bulk of their bodies, which
receives less light than their backs, and
the darkest tone is their undersides, which
turn away from the light into shadow. This
gradual change in tone tells us they have
rounded forms.

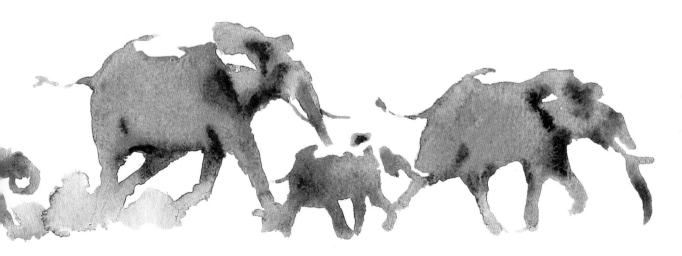

Rounded forms

A gradual change from light to dark implies a rounded form. Wet into wet is therefore the best technique to show roundness as the blends graduate.

Stage 1: Untouched highlights are left out of a circular wash of Indian Yellow.

Stage 2: An orange colour made from mixing Permanent Rose with Indian Yellow is touched into the damp wash from the darkest side, and more intense colour is gradually added until the required strength is achieved to make the orange fruit appear spherical.

△ Rounded forms can also be concave, like the interior of this cylinder. By darkening the tone, wet into wet, on the inside of the pot, it immediately looks cylindrical.

Angular forms

Angular forms have defined edges, so the wet-on-dry technique can delineate these perfectly (see page 56).

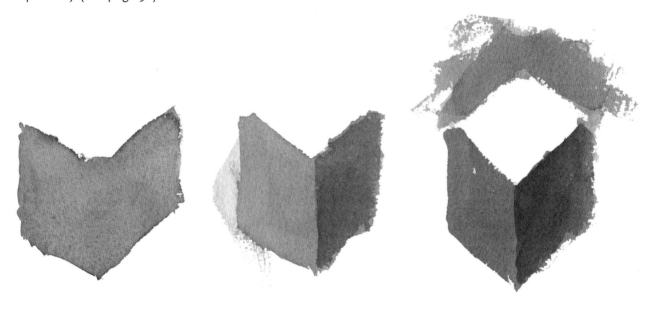

△ A wet-on-dry tint over the chevron shape, plus the hint of background, immediately suggests the angular form of this cube.

Space and depth

Space can be alluded to in painting, and makes an interesting watercolour. The illusion of space can be created through the careful use of light and shade and by perspective.

◁ Usually the lightest and darkest tones are in the foreground with less contrast in the distance. By pitching a darker tone adjacent to a lighter tone, the darker tone implies that it goes behind the lighter area in front of it.

▷ **Boston Skyline** *(20 x 28cm / 8 x 11in)* When a subject is backlit, the farthest distance will appear paler and more muted than closer objects, which become darker as they approach. The difference in tone suggests distance.

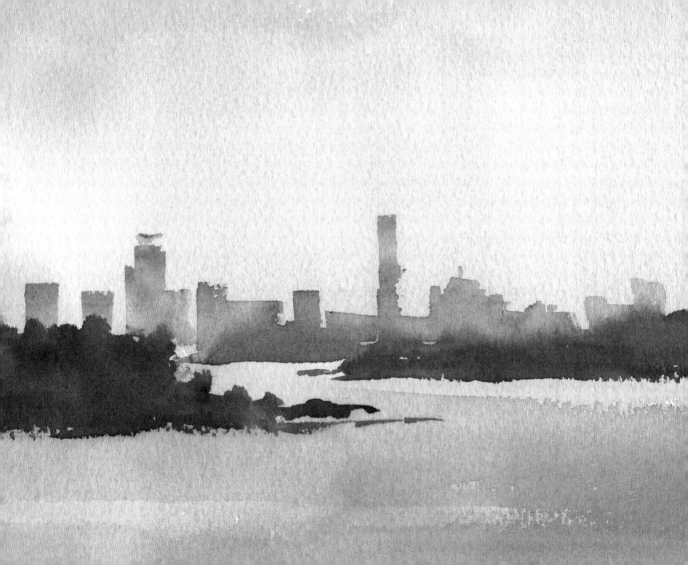

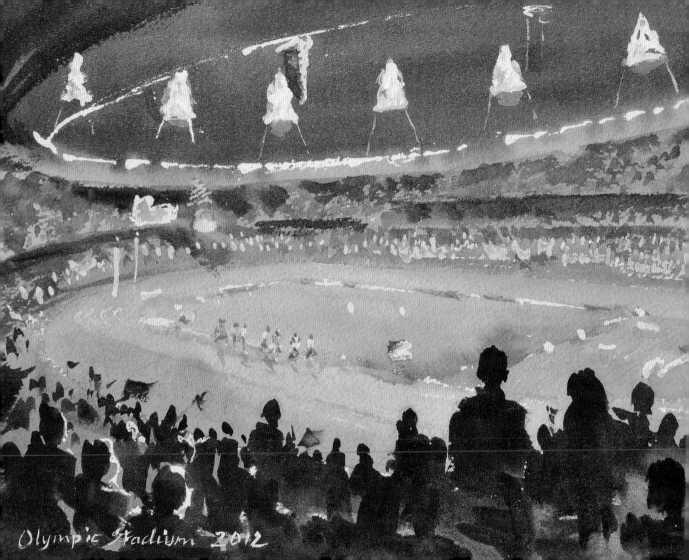
Olympic Stadium 2012

Perspective

Perspective can be used to imply space or distance. Objects made smaller appear to be in the distance, larger objects appear closer.

▷ The fence posts diminish in size as they go further away and the parallel ruts in the road come closer together, creating a sense of distance and space.

◁ **Ring of Excellence**
(25 x 30cm /10 x 12in)
The vast scale of the Olympic Stadium in London is created on a small piece of paper by showing the figures in the far distance as very small and those in the foreground as much larger.

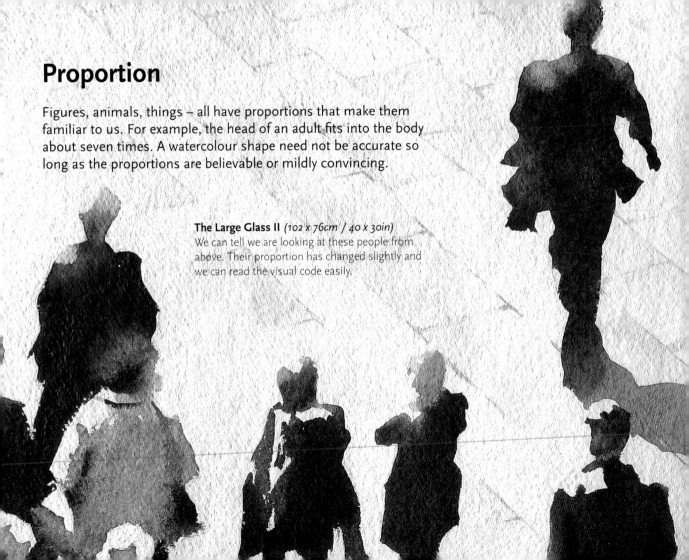

Proportion

Figures, animals, things – all have proportions that make them familiar to us. For example, the head of an adult fits into the body about seven times. A watercolour shape need not be accurate so long as the proportions are believable or mildly convincing.

The Large Glass II *(102 x 76cm / 40 x 30in)*
We can tell we are looking at these people from above. Their proportion has changed slightly and we can read the visual code easily.

Designing the picture

A watercolour painting does not have to be complicated or full of activity to succeed. Watercolour welcomes simplicity. The beautiful passages of blending and overlapping colours are attractive enough in themselves. Most paintings do, however, benefit from a focus, which will usually be what drew your attention to the subject in the first place and what you are most interested in.

As a rule of thumb, it is better not to position main features bang in the middle: placing them to the right or left of centre will make a more interesting composition. The same applies to the horizon. The 'rule of thirds' (see opposite) works well in general, but remember that rules in art are also made to be broken.

Don't be a slave to veracity

Don't try to copy your subject exactly; it is the inspiration for your watercolour and you are under no obligation to mimic it. A painting has a life of its own; it is a new creation and you can change anything in the subject to suit your watercolour. Oscar Wilde puts it perfectly: 'Art begins where imitation ends.'

▷ In this detail these are just blobby brushmarks but, even so, we interpret them as two women conversing by a boat.

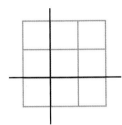

△ Rule of thirds

Positioning your focus or feature a third in from the left or right makes for a better composition balance than right in the centre.

▷ Gargnano
(25 x 28cm / 10 x 11in)
In this quick sketch, the vertical line of the tree is about a third in from the side and the harbour wall about a third up, giving a satisfying balance to the composition.

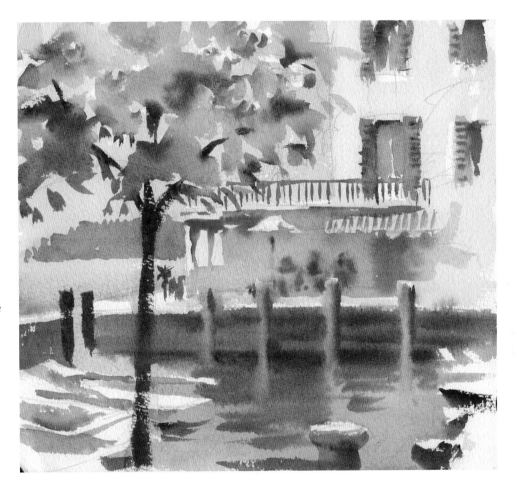

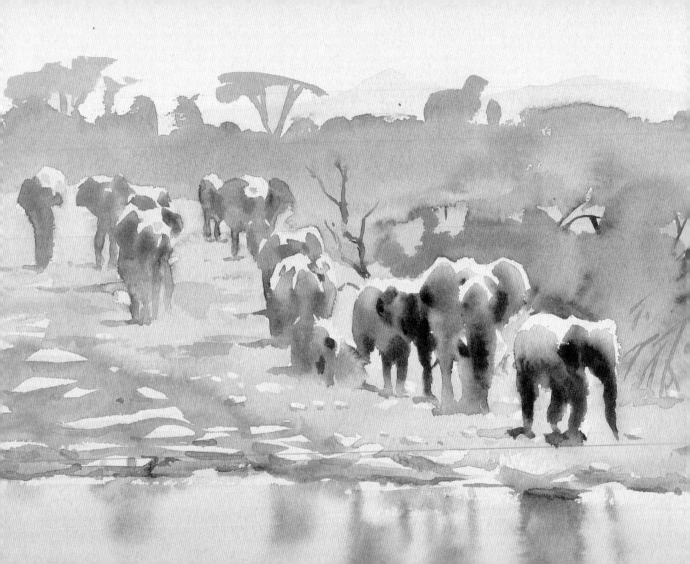

Knowing when to stop

If the watercolour on the paper looks lovely, you can stop at any time. You do not have to 'finish' a watercolour. Because it is on paper, you can crop off anything that doesn't work anyway and even change the focus of the painting.

Don't try to 'tidy up' your watercolour: ambiguity is one of the lovely characteristics of blending. The technique termed 'lost and found' exploits the vanishing substance of features as they melt in hazy shadow and gain definition in the light.

Most of all, do not fiddle. Overworking watercolours kills off freshness. If I am unsure whether something is finished or not, my motto is: 'If in doubt, chicken out'!

◁ **The Attraction to Water** *(30 x 41cm / 12 x 16in)*
The herd of elephants approaching the water is implied by shapely but fairly vague brushmarks and alternating light and dark tones. Proportion, shrinking size and fading tone suggest distance ... but most is left to your imagination.

CHAPTER 6

Go for it!

Have fun, relax and enjoy! The process of painting is seeing, mixing, laying brushstrokes and blending colours – the rest will come in time.

Gaining confidence

If you have the desire to paint and want a medium you can use anywhere, watercolour is ideal. It is a direct, quick-drying medium that requires only the minimum of tools and materials which are lightweight and easy to transport. More importantly, you can get wonderful results right from the start.

Experience comes with practice and with practice comes excellence, but this little book gives you the basics – you are now ready to make your first watercolour painting ... and watch out for the adrenaline rush!

▷ **Running for Joy**
(56 x 76cm / 22 x 30in)

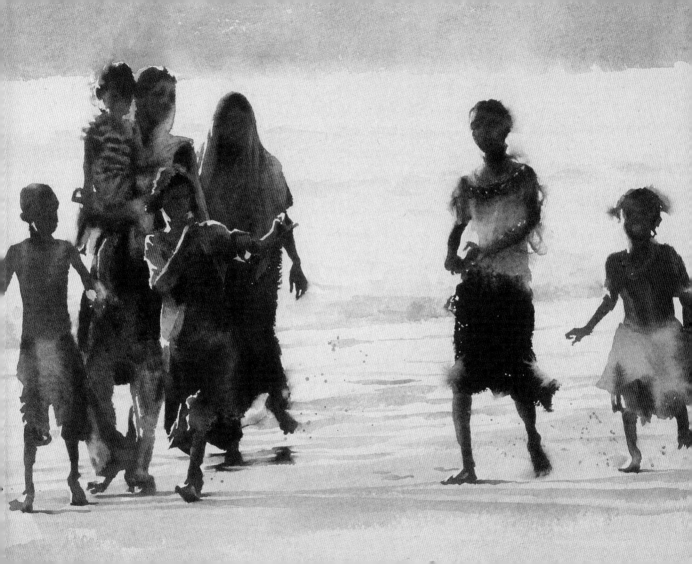

Index